Paradise On Earth

Project, Marketing And Management Consultant
Astrology, Palmistry & Numerology Adviser
Vastu, Spiritual And Herbal Therapist
Lyricist, Poet, Artist And Composer

I0405140

By

Aditya Kumar Daga

Paradise On Earth

By

Aditya Kumar Daga

Preface

The Cool breeze whistling through the larch and firs, pines and oaks, ice-cold sacred streams of holy and sacred rivers merrily gurgling over boulders and rounded pebbles, birds doting the azure orange blue multi color skies full of willowing clouds and down below valleys of quaint towns and sturdy hill side village huts and hamlets, towering temples on hills and mountains taking everyone's breathe just on thinking the architectural dangers behind such construction on the top of the mountains after passing through narrow ranges of old sandy streets and roads below the mountains on one side and thousands feet deep valleys on the other side of such streets make us believe that only nature can give you such paradise on this earth.

The melancholy beauty of deserts, the plateaus of sands, the absconded forts, the solitary splendid palaces, mellowing stately homes, deserted pinnacles, isolated ancient temples, sensitizing historic stretches of turmoil & turbulence, art deco palaces, vividly testifying the glory of royal kingdoms, wide stretches of sand domes, sand huts, sand hills, sand colored forts and sand valleys, heart throbbing shows of wandering minstrels, warbling flutes and euphoniums over desolated songs of forlorn tribes causing unresisting impulse of mix stings of curiosity and interests that only nature can give you such paradise on this earth

Lazy sunbathing, wind surfing and snorkeling along the wide stretches of serene sea shores and beaches, far distant in the sea and wide rivers marine boats playing with the waves and high tides, fishermen carrying and sailing far deep into the sea with their long & wide fishing nets, a wide unending stretches of enlightened candles on horizon mixing the sky and earth throbbing the heart like bubbling waters, long repetitive waves stroking against the mountains, beauty of resort ships and racing boats lured everyone to think that only nature can give you such paradise on this earth.

Different shades of atmosphere and environment in seasons of spring, summer, rains, autumns, pre winters, winters, different shades of sky at different times of dawns, early mornings to mornings , afternoons, evenings, late evenings, early to late nights with waning & waxing moon skies, different moods of wave of winds & water, different shades of rays of sun & moon make you think thousand times that only nature can give you such paradise on this earth.

Whenever I was on long journeys and travelling I always felt as someone unknown is pulling me hard towards an unknown world and losing me into a world of large screen , me and heart throbbing scenes. No cameras No flash lights, no candle lights, no moon or sun lights, but something in me scanning that beauty forever and storing it deep into my soul traveling through my eyes and heart. All such beauties of nature's paradise is still locked in my soul & heart. So I believe that only nature can give you such paradise on earth.

Aditya Kumar Daga

Original Art Work Collections

Pencil-sketched And Water Color-painted,

Arts of our 'Paradise On Earth'

(Mother Nature & it's Irresistible Beauty)

Imagined & Composed
By
Author & Artist
Aditya Kumar Daga

Arts developed during the Years
1987-1989

Published First Time 5th October 2016

Original Arts size 6"*4"
Presenting in Micro Size of 3"*2"

Author & Artist

Aditya Kumar Daga

3C Gopi Bose Lane Kolkata-700012; W.B; India

www. adityaastroworld@gmail.com

Email: adityaastroworld@gmail.com

Mob: +91 9432221255, +91 8961429776

First Edition on 05th October 2016

Paradise On Earth
Original Art work Collections
Copyright @ Aditya Kumar Daga No Part shall be copied or produced or reproduced without the written permission of the Writer, Artist & Author
Aditya Kumar Daga

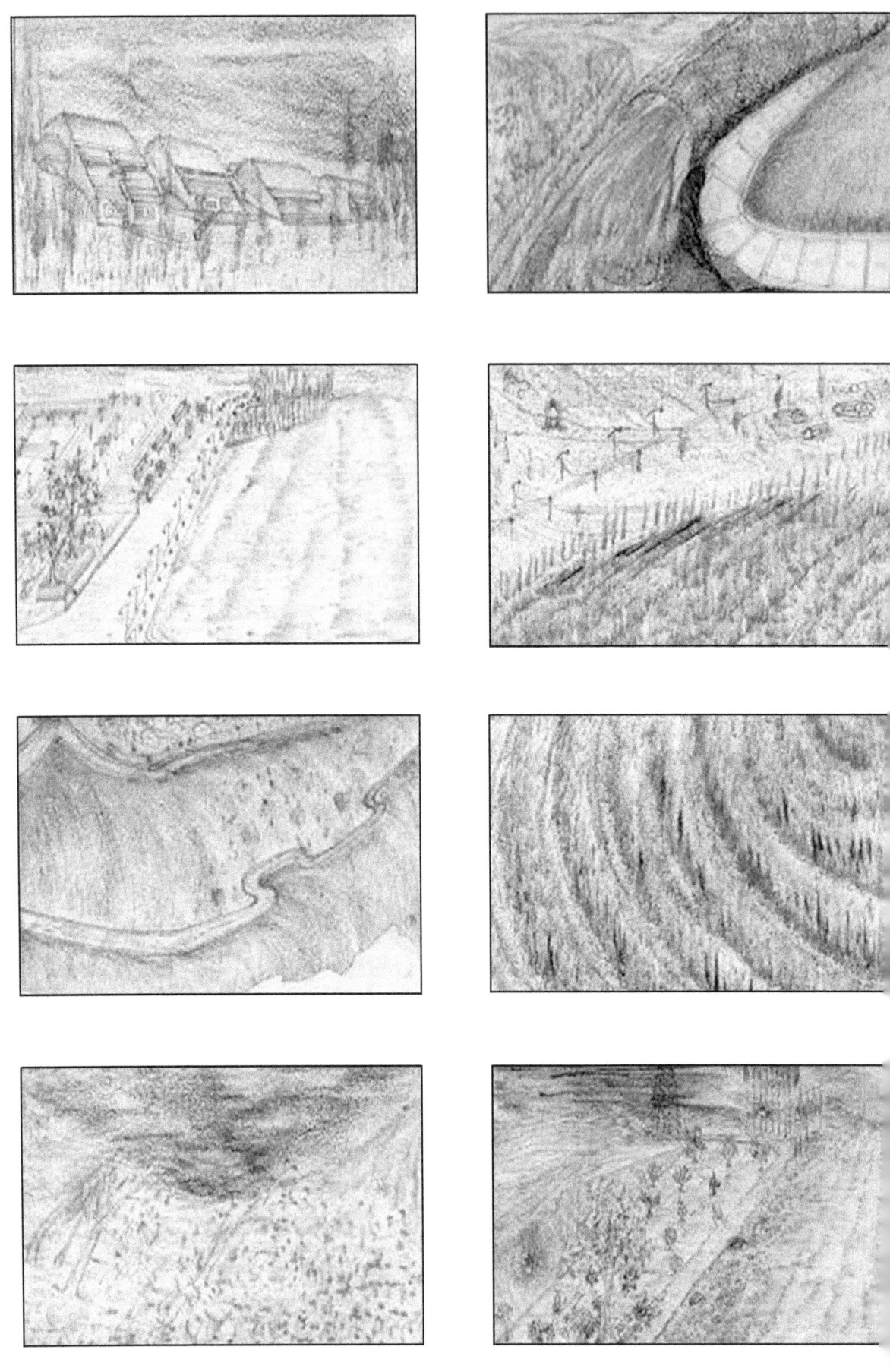

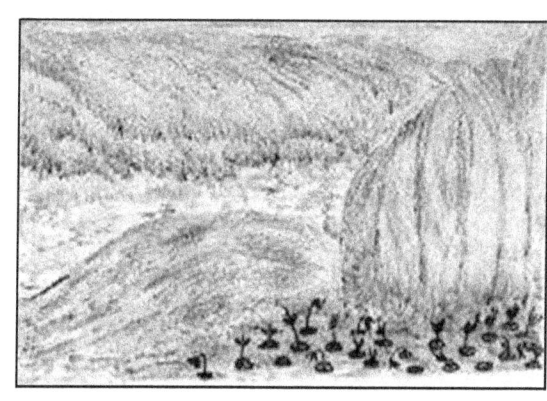

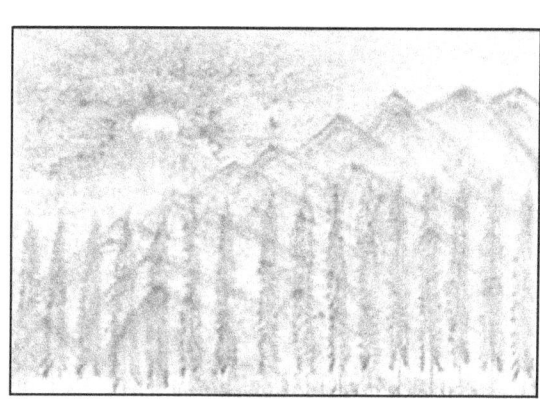
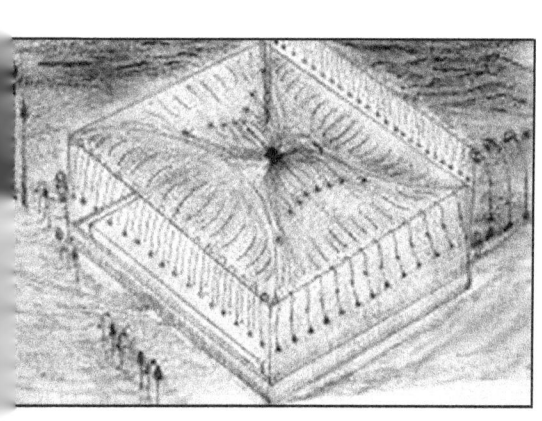
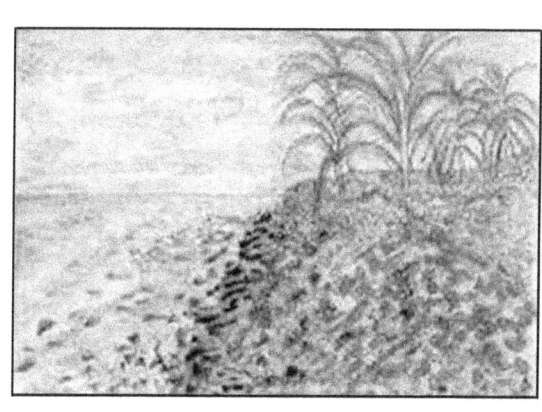
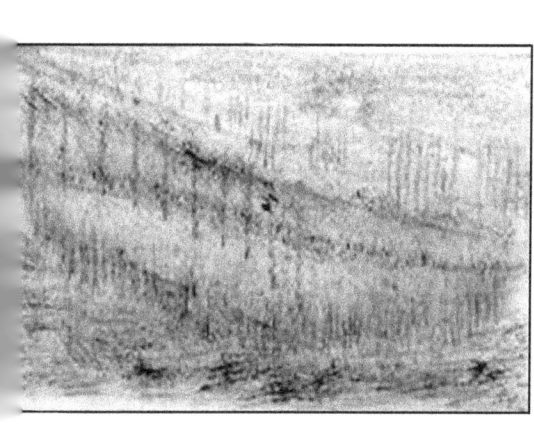
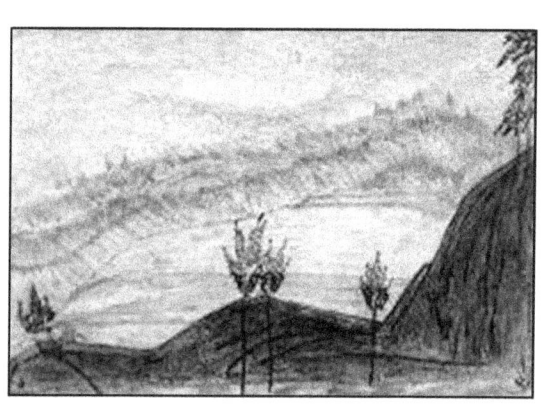

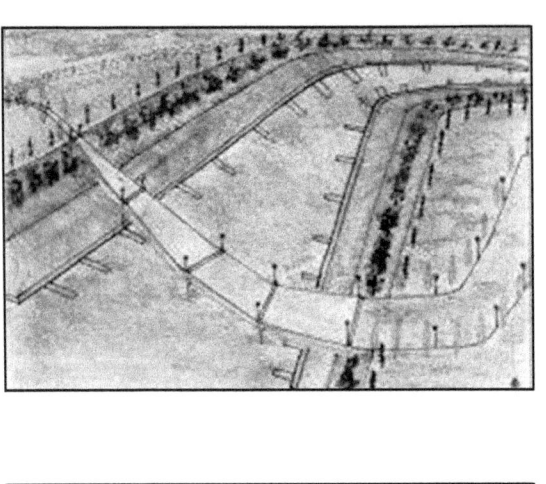
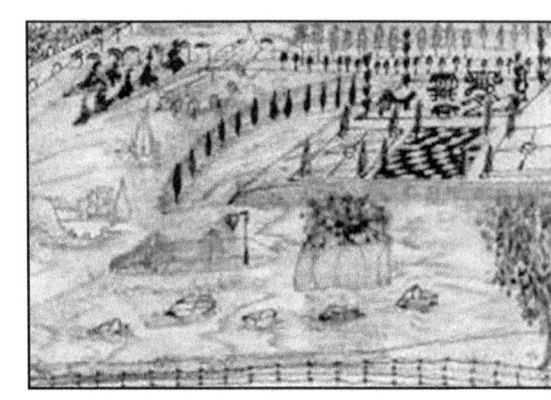
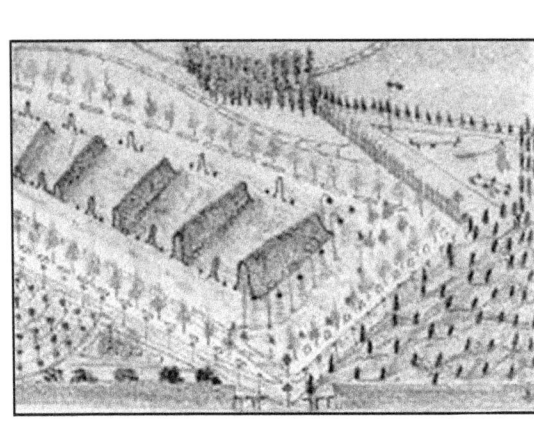
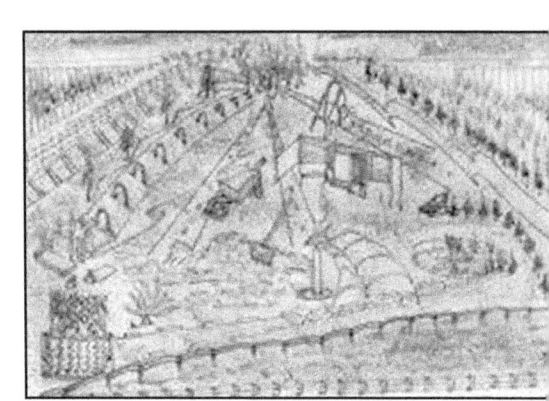
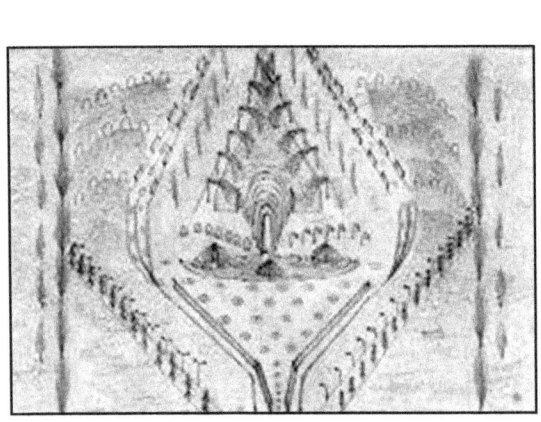
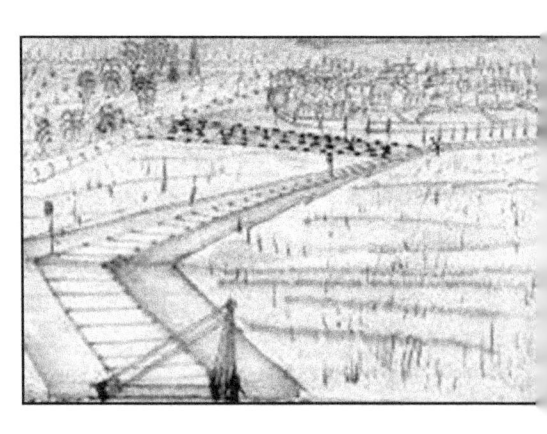
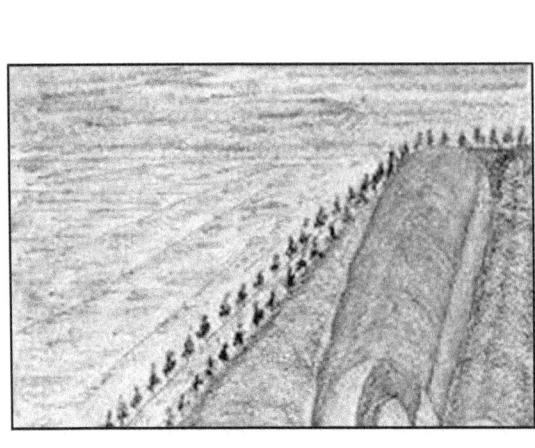

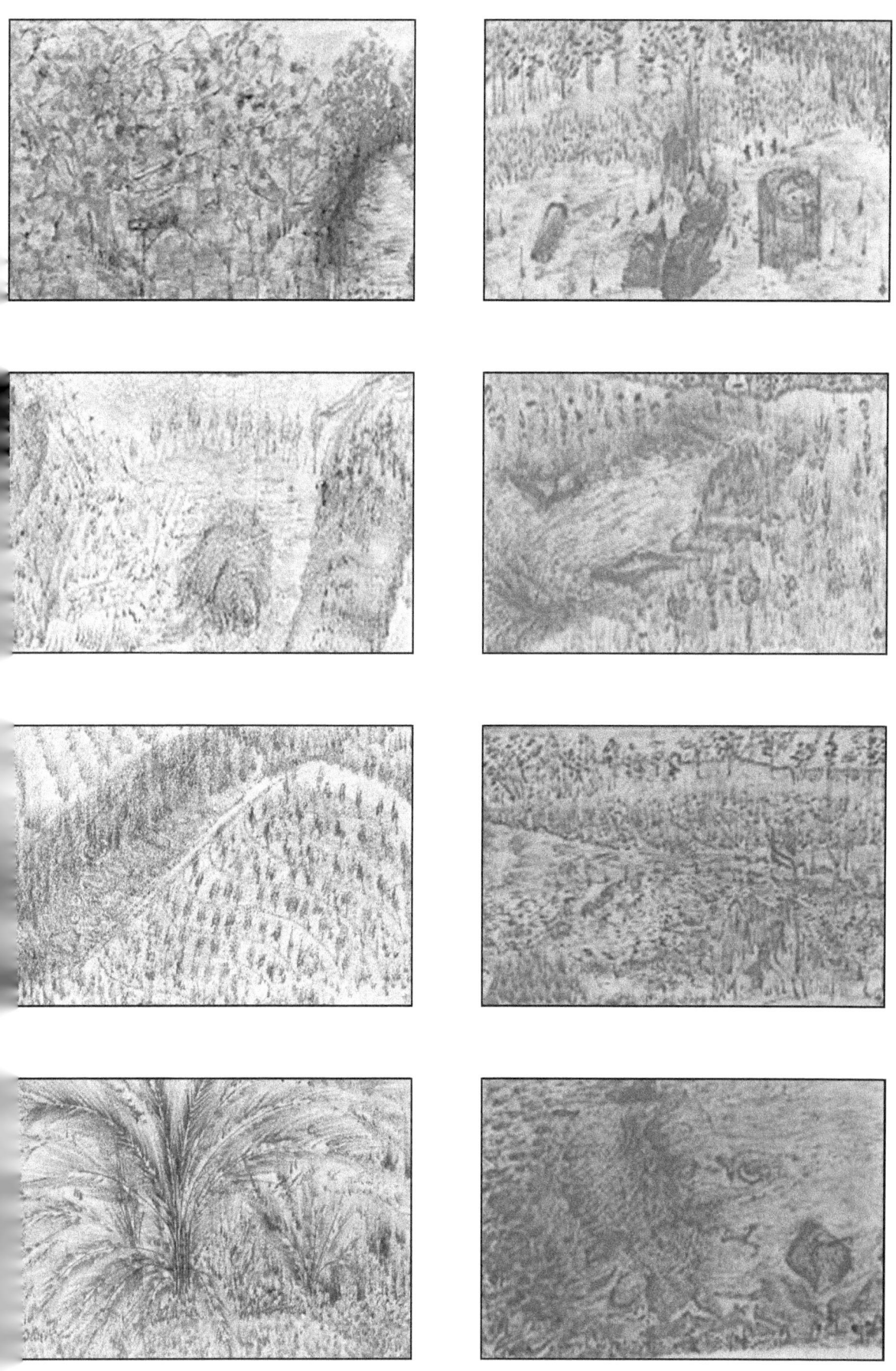

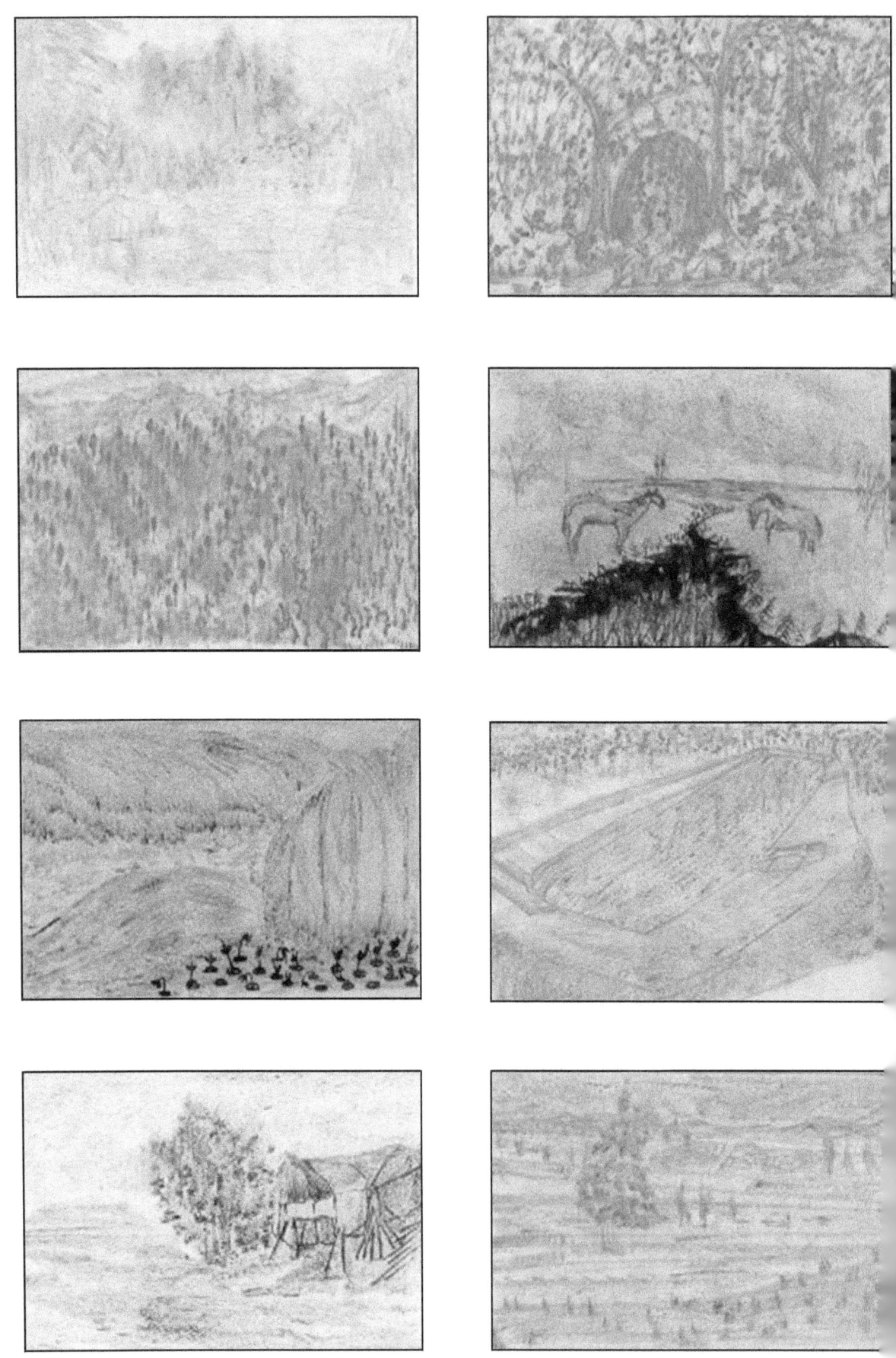

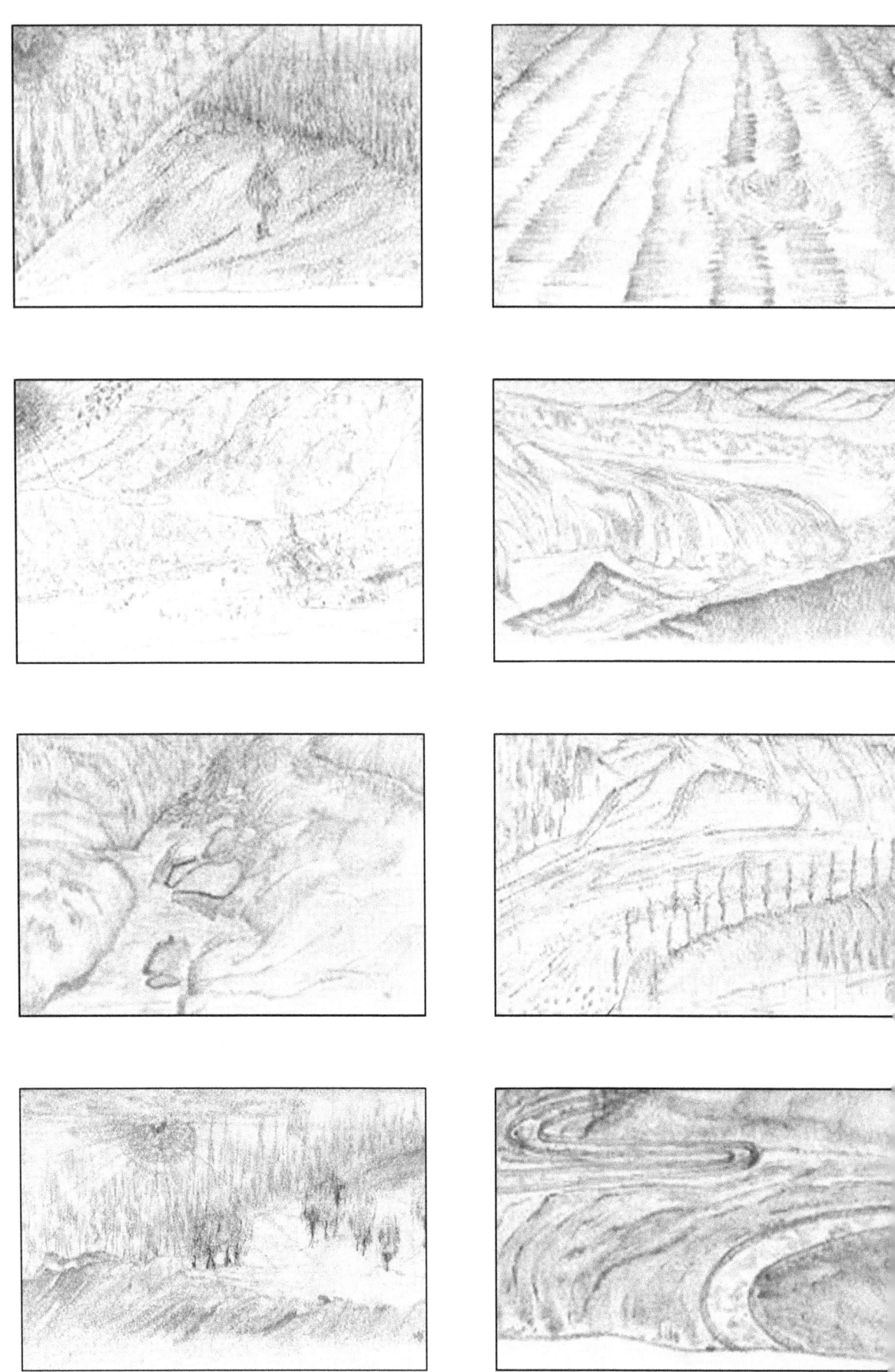

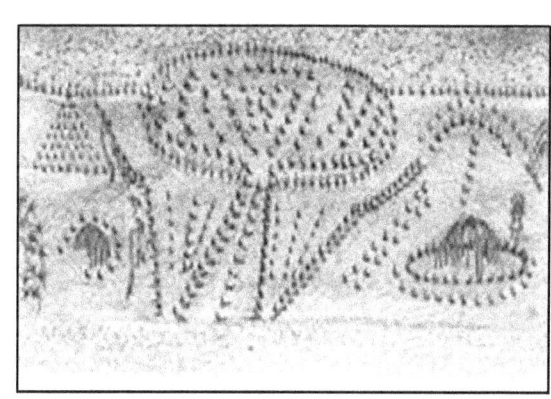

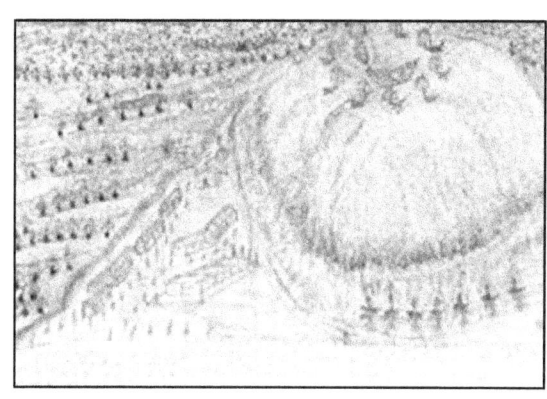
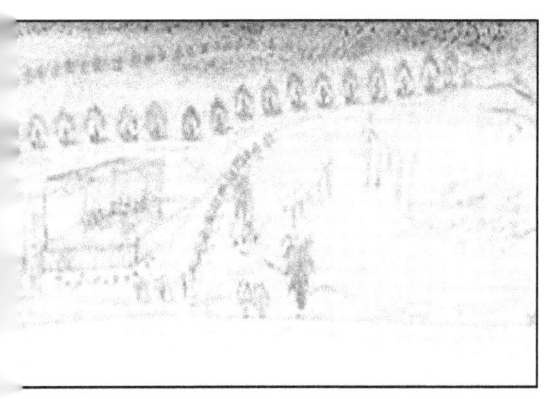
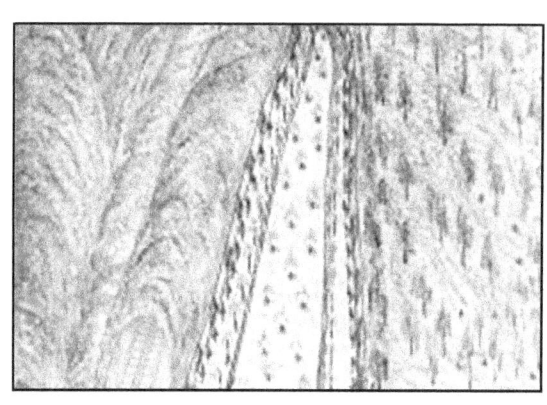
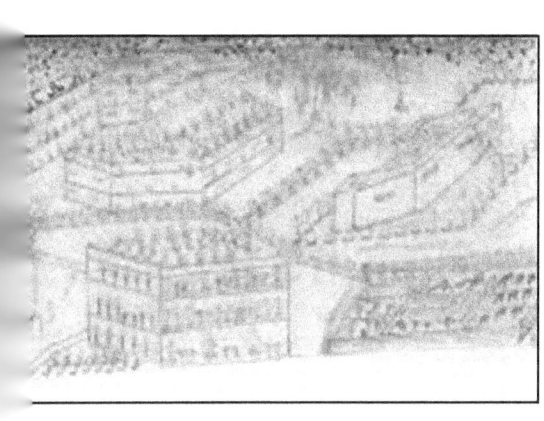
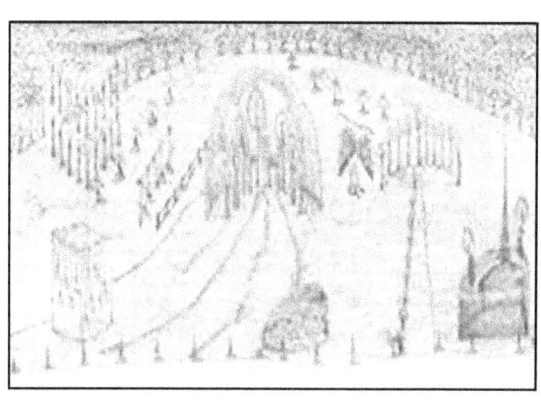

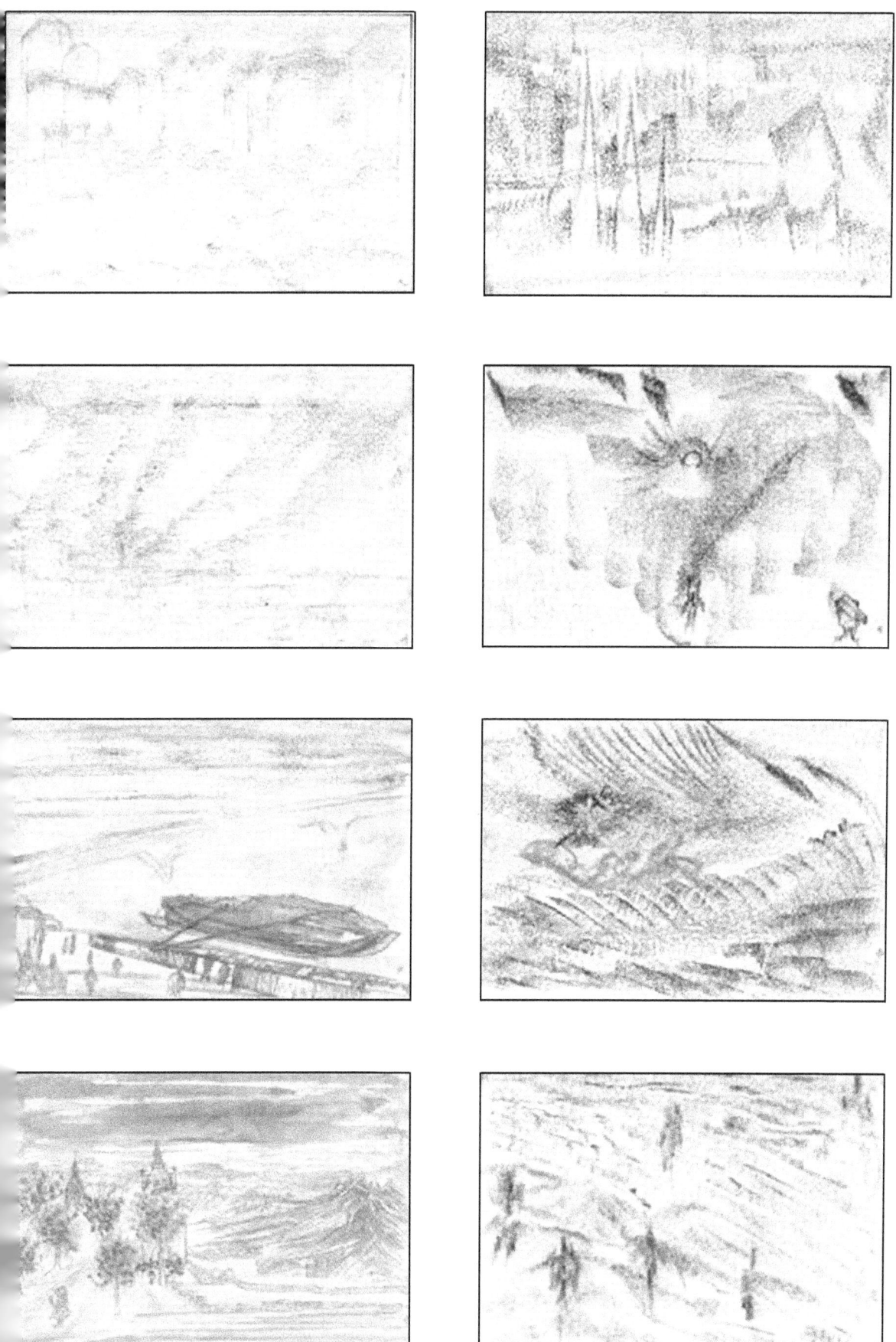

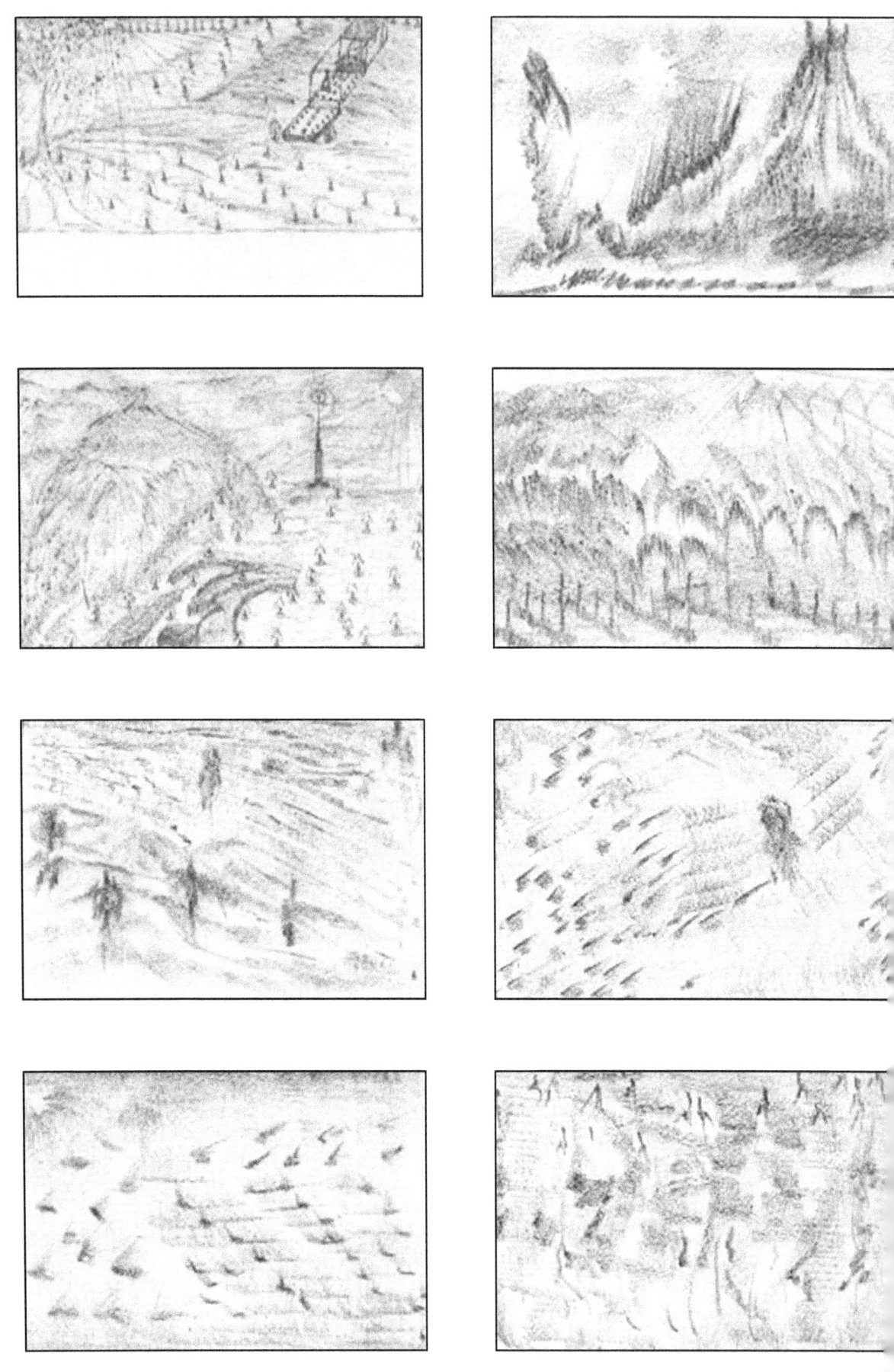

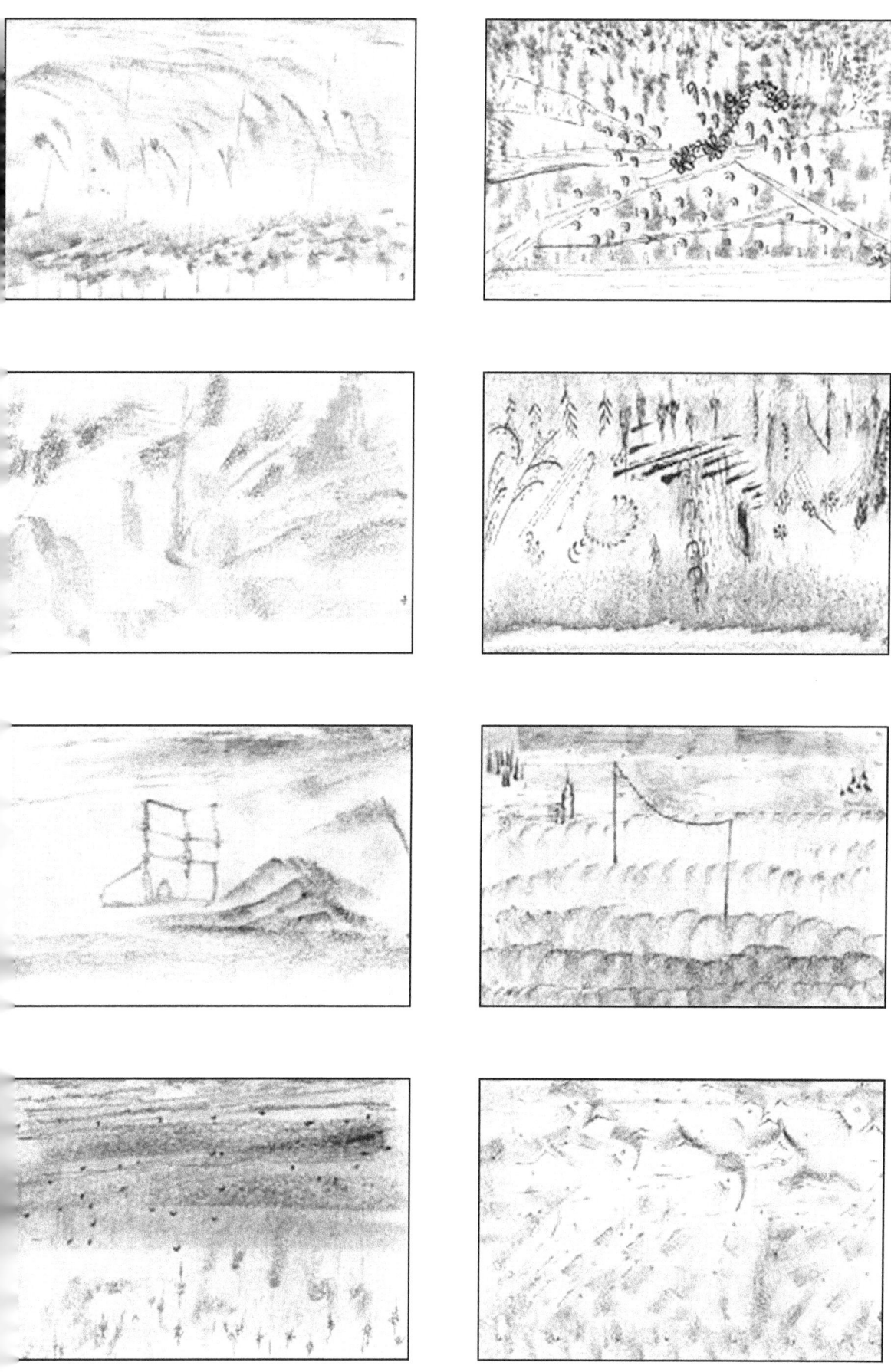

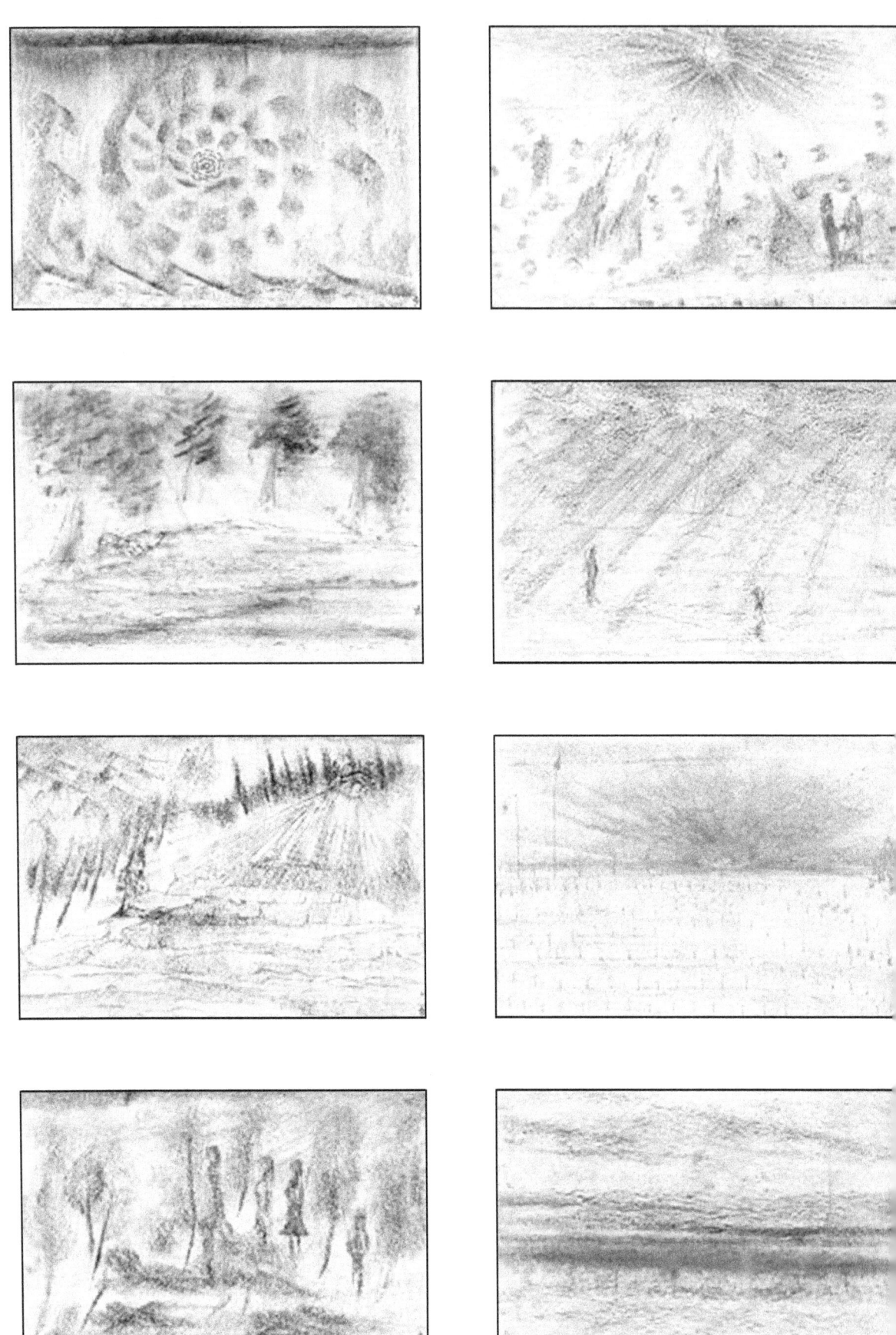

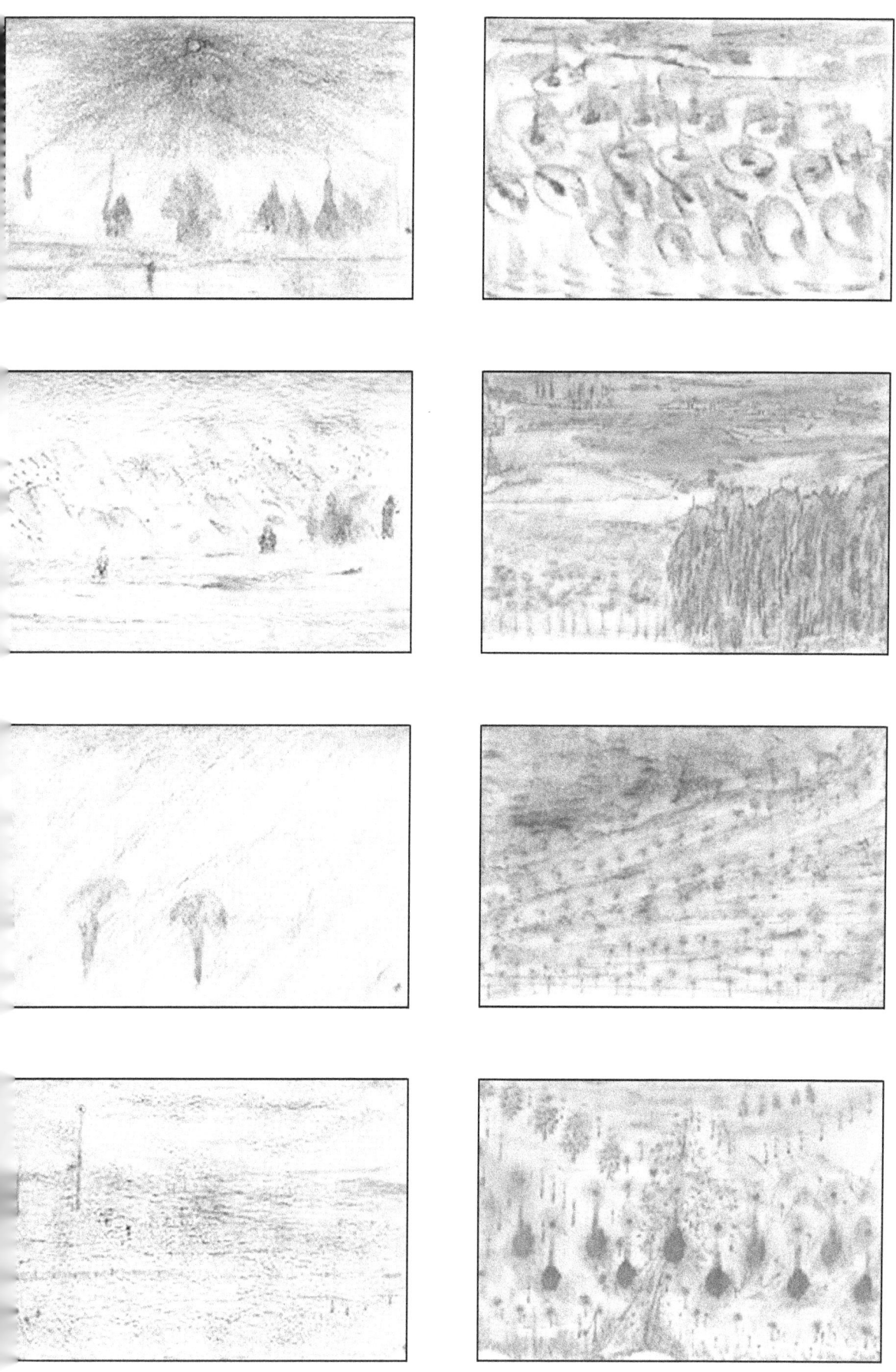

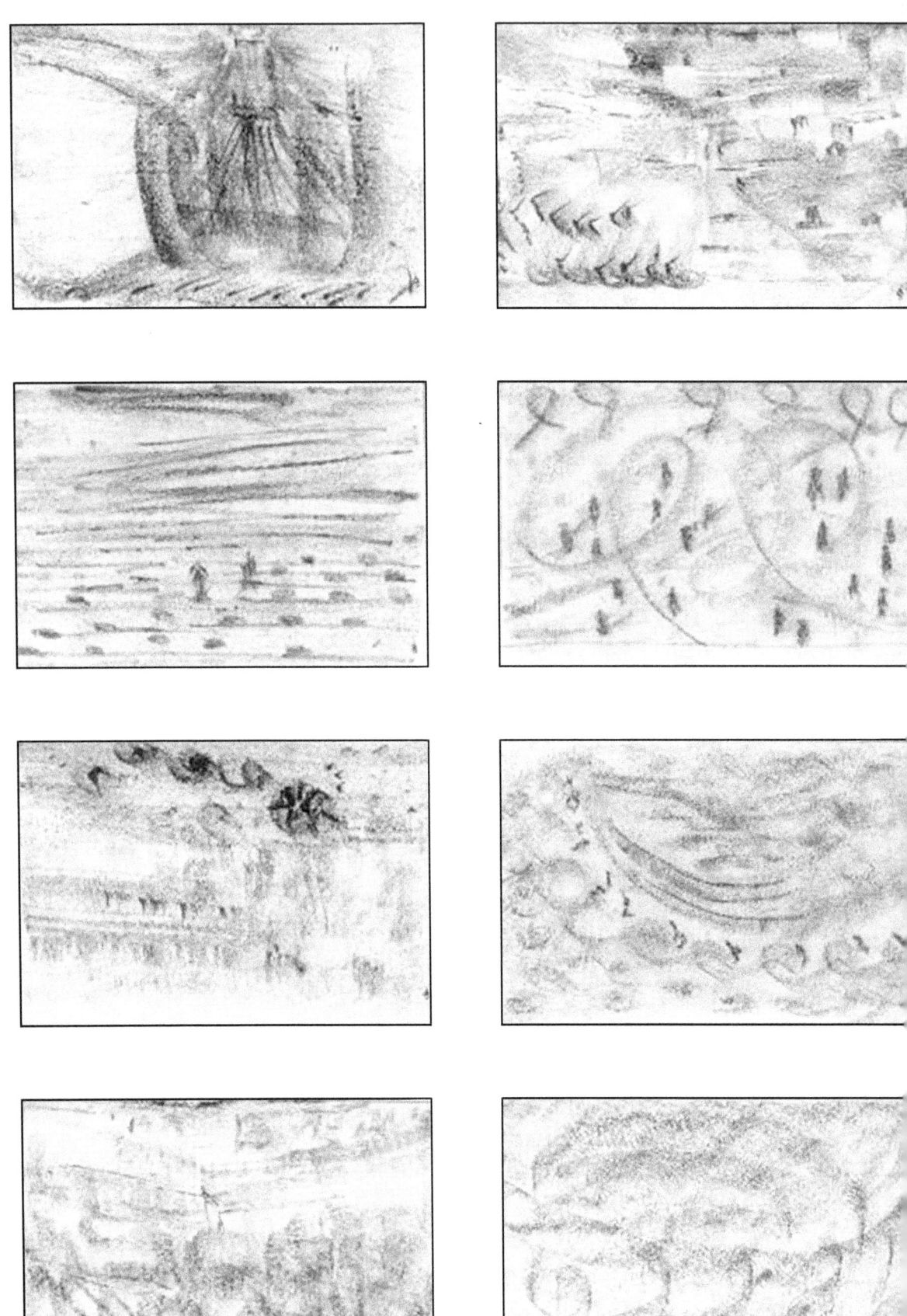

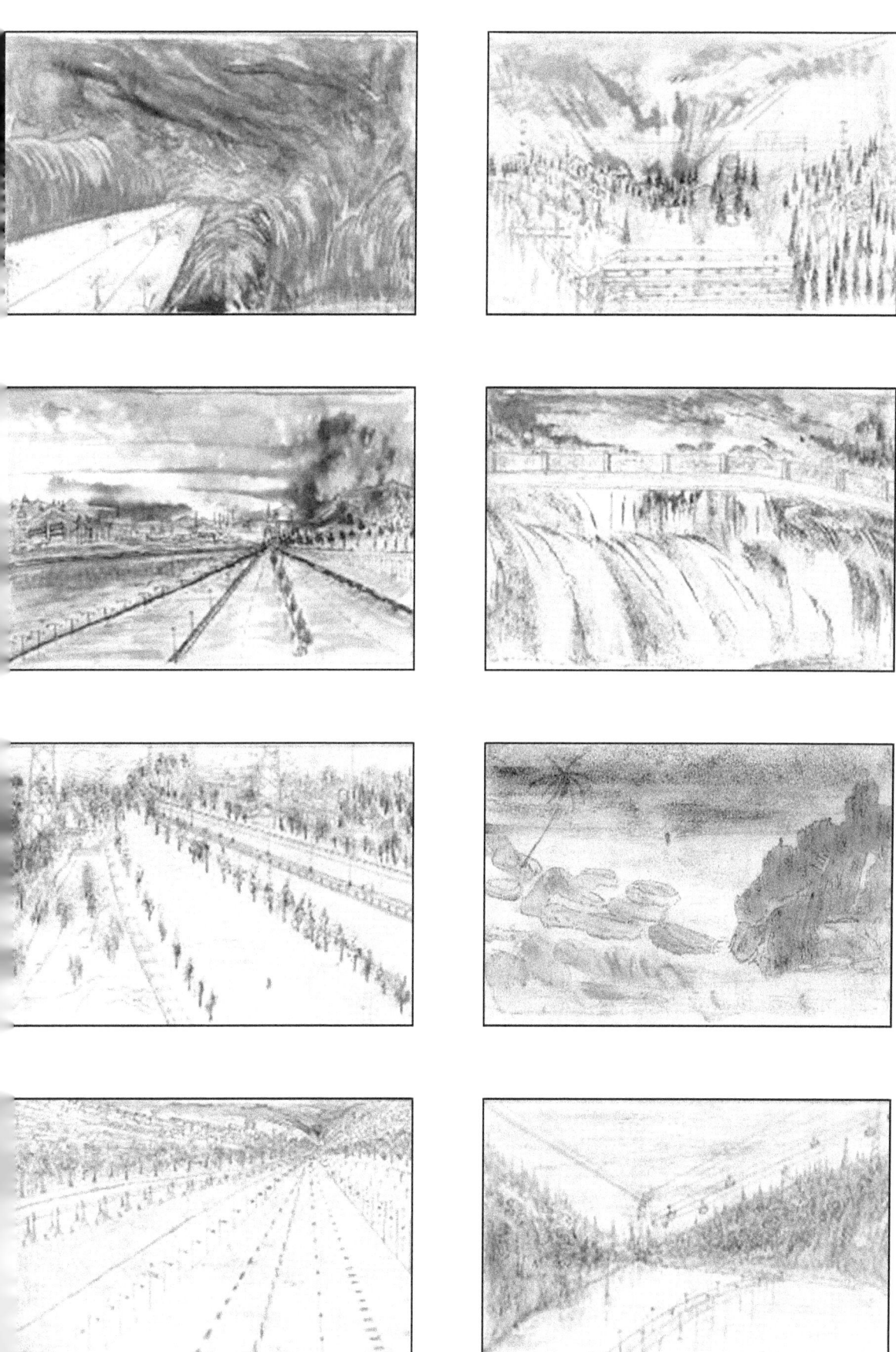

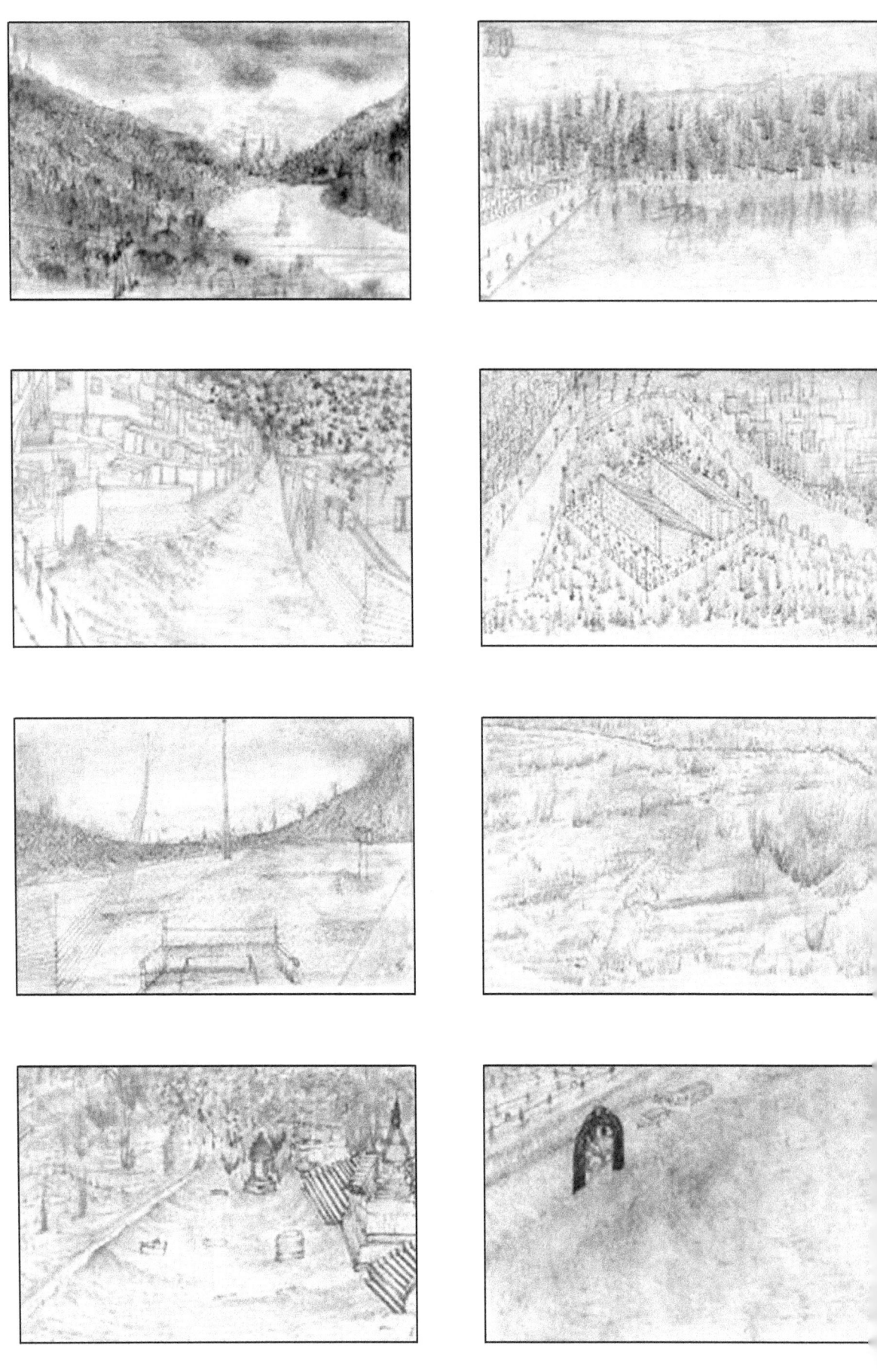

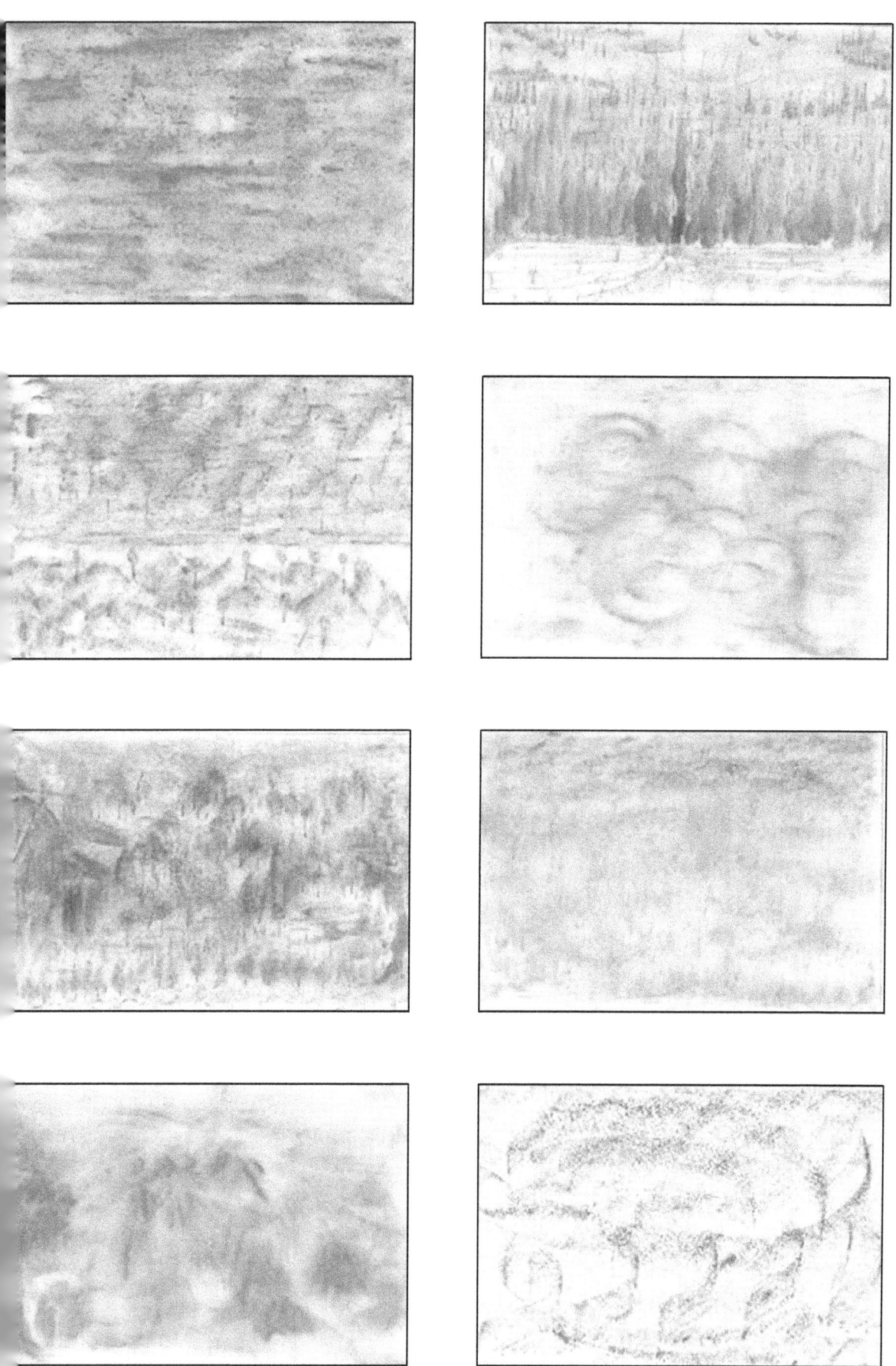

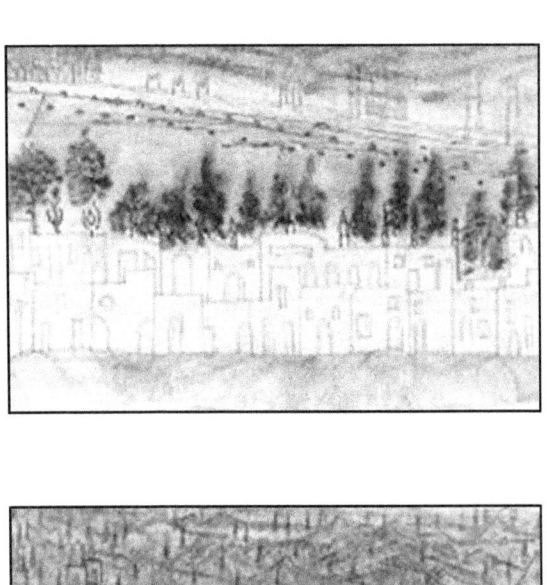
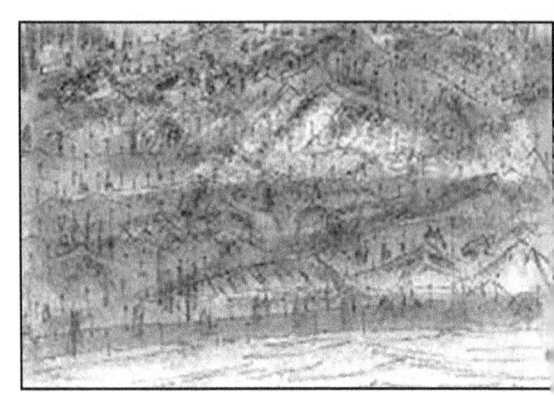
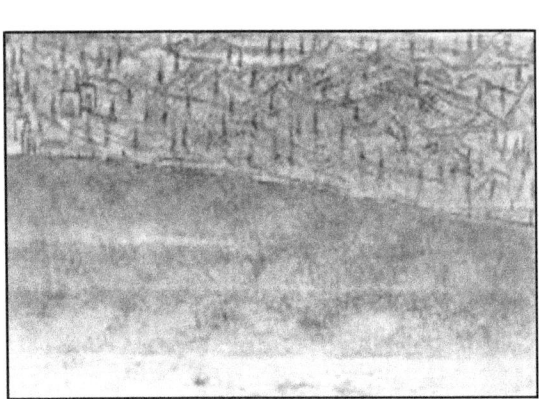
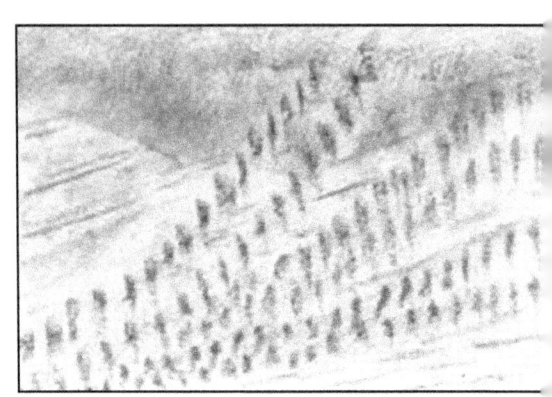
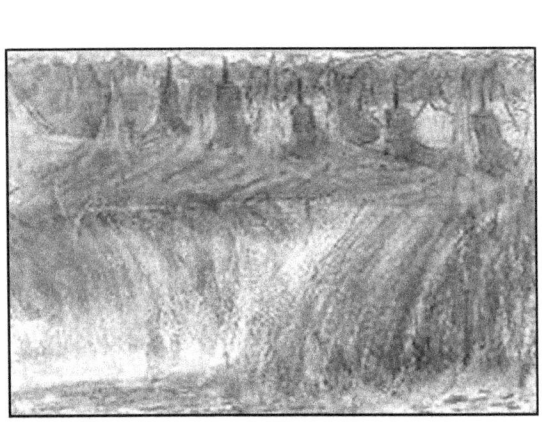
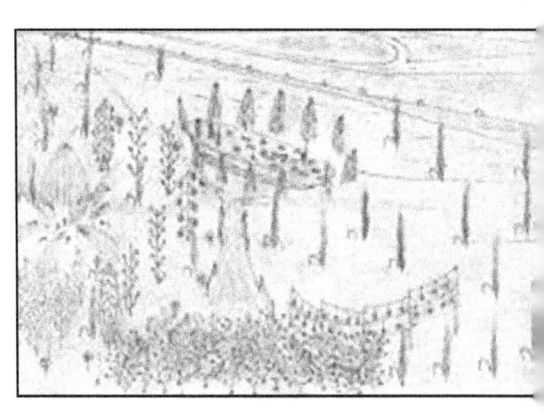
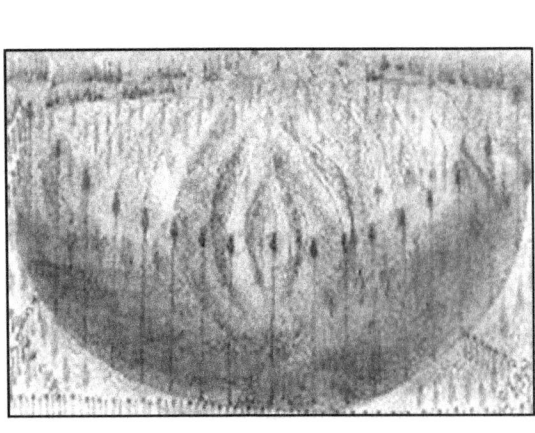
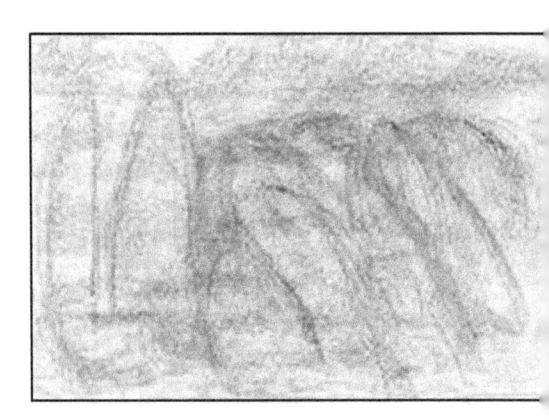

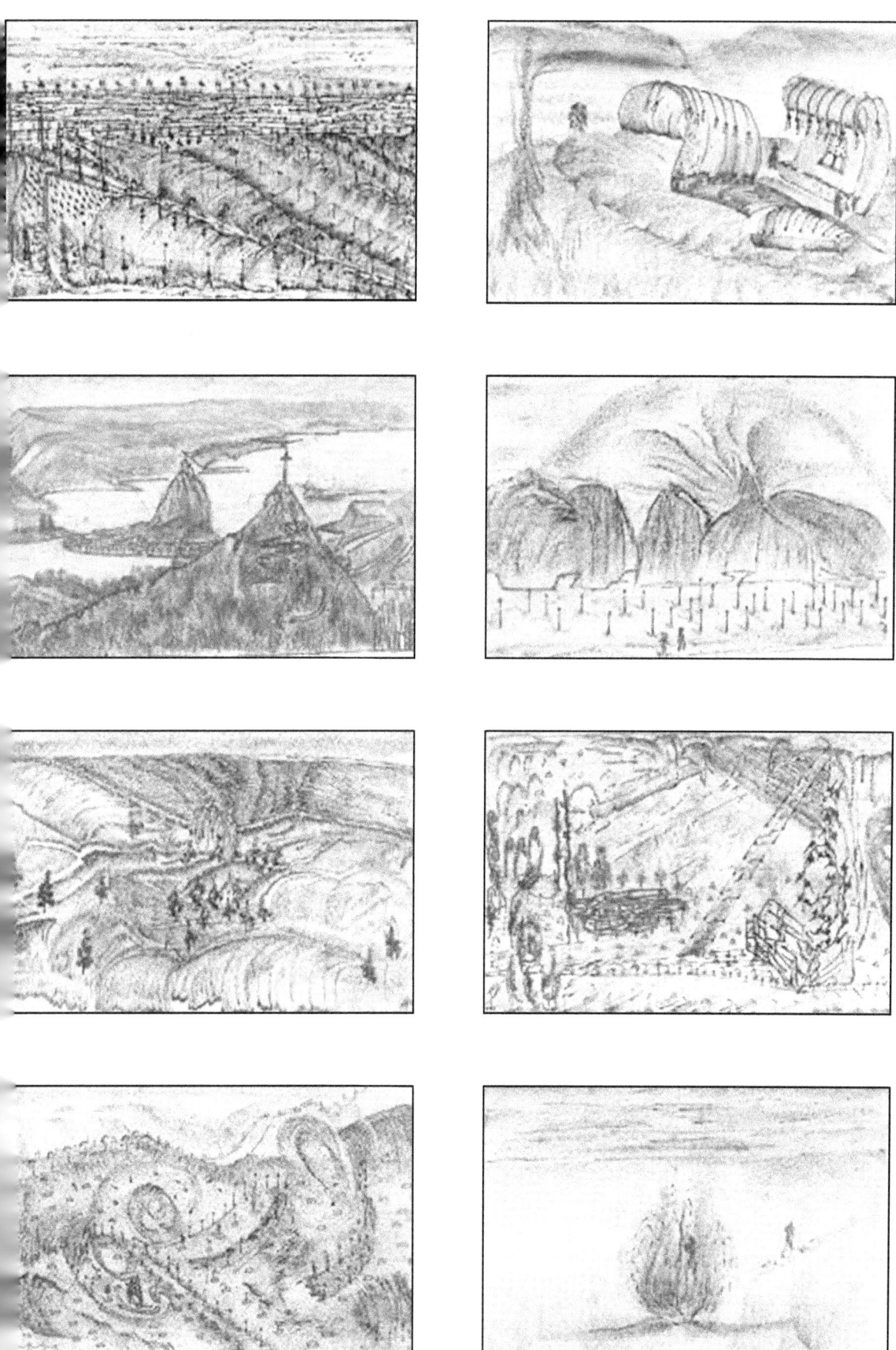

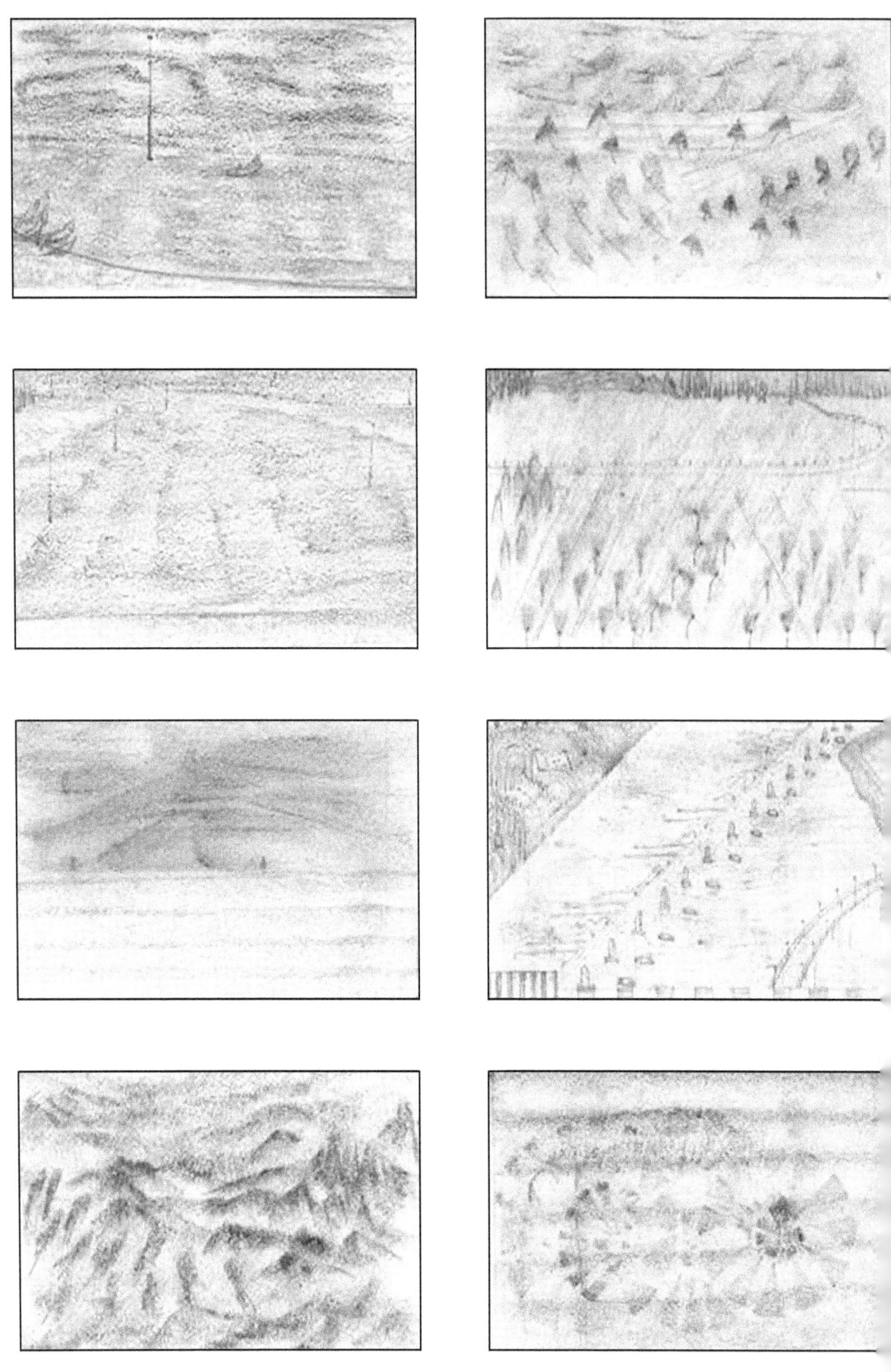

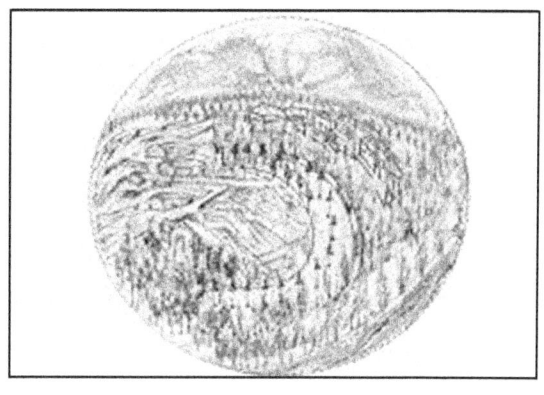

So this tour to my gallery ends here

Love this Paradise on earth

Love the Mother Nature

Don't destroy it's beauty

Don't make it aged & old

Let it look young & beautiful

Irresistible & Invincible

Mesmerizing & charming

Splendid & magnificent

Vivid & Glorious

<div style="text-align: right;">Aditya Kumar Daga</div>

Paradise On Earth is a collection of original Art Works on irresistible beauty and different moods of nature in different time, seasons & weathers.

By Aditya Kumar Daga

www.ingramcontent.com/pod-product-compliance
Lightning Source LLC
Chambersburg PA
CBHW080532190526
45169CB00008B/3121